THE BRITISH MUSEUM
LOVE
AND
MARRIAGE

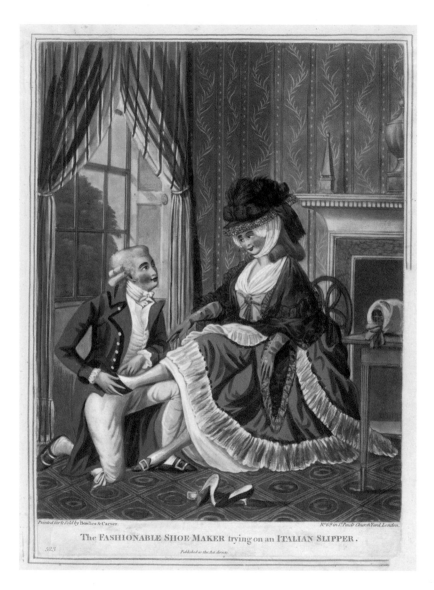

Printed for & Sold by Bowles & Carver.

Nº 69 in St Pauls Church Yard, London.

The FASHIONABLE SHOE-MAKER trying on an ITALIAN SLIPPER.

Published as the Act directs.

THE BRITISH MUSEUM

LOVE
AND
MARRIAGE

Jennifer Ramkalawon

THE BRITISH MUSEUM PRESS

© 2009 The Trustees of the British Museum

Jennifer Ramkalawon has asserted the right to be identified
as the author of this work

First published in 2009 by The British Museum Press
A division of The British Museum Company Ltd
38 Russell Square, London WC1B 3QQ

www.britishmuseum.org

A catalogue record for this book is available from the British Library

ISBN 978-0-7141-2663-0

Frontispiece: *The Fashionable Shoe-Maker trying on an Italian Slipper*
Published by Carington Bowles. Hand-coloured mezzotint, 1784

Photography by the British Museum Department of Photography and Imaging
Designed and typeset in Centaur by Peter Ward
Printed in China by C&C Offset Printing Co., Ltd

CONTENTS

INTRODUCTION
6

COURTSHIP
10

DISAPPOINTED LOVE
18

TEMPTATION
30

MARRIAGE
50

ILLUSTRATION REFERENCES
96

INTRODUCTION

The Pleasure of a married State consists wholly in the Beauty of the Union, the
sharing Comforts, the doubling all Enjoyments; 'tis the Settlement of Life.
Daniel Defoe, *Treatise concerning the use and Abuse of the Marriage Bed* (1727)

Marriage has many pains but celibacy has no pleasures.
Dr Johnson, *Rasselas* (London, 1759)

THESE two contrasting quotations about the married state, one hopeful,
the other cynical, are perfectly reflected in two prints of *c.* 1774 (see p. 8).
In *The Pleasures of a Married State* a contented couple survey their 'smiling off-
spring'. The pair are equal partners in their marriage as they exist 'in mutual love'
and both 'rule and obey'. However, there is a compromise; the woman will
always be subservient to the man as 'her charms obedient to his judgement
sway'. Despite this, they are united in love.

Compare this picture of marital bliss with the empty, depressing world of
the bachelor, as described in the companion print, *The Miseries of a Single Life*. A
miserable man, suffering from gout (a sign of his previous dissipated lifestyle),
is confronted with a pregnant girl and her mother, who have clearly come to
claim some sort of financial renumeration. A similar sentiment is expressed in
a slightly earlier print by Louis P. Boitard, which dates from around 1760 and
highlights one of the many consequences of a dissolute existence. In the print,
entitled *The Enrag'd Bachelor, or The Plague of a Single State*, a man stares in disgust at
the crying baby in a basket that has been left for him, clearly labelled 'to Simon
Spindleshanks Esq.'; the moralizing verse beneath leaves the viewer in no doubt
as to his fate:

Batter'd, deseas'd, and past his youthfull pranks,
Lo here a bantling, laid to Spindleshanks.
Long thro the Fields of lawless love he rang'd,
And with his Dress his Mistresses he chang'd;
Inmate with all the brothels of the Town,
To every Quack was intimately known;
Distain'd the Shackles of the Nuptial Noose,
Nor for the world his Liberty wou'd loose.
Hymen, enrag'd for his unvalu'd Rite,
Resolves to punish the audacious Wight,
Send him when impotent a spurious Brood —
Teague grins to see his Brat so well bestow'd.

The twist is that the child is not even his son, but rather the bastard offspring of the other gentleman in the print, who gesticulates behind Spindleshanks smiling knowingly at the viewer.

The path of true love in the eighteenth century was fraught with danger. Temptation was rife, sometimes resulting in an unwanted child, as in the Boitard print. This was an inconvenience for a man but would mean true hardship and social ostracism for a woman. Unrequited love was always a popular theme in the visual arts, and caricatures were no exception: there are endless prints of weeping females abandoned by their sweethearts or mourning the loss of a faithless lover. However, the married state was not one of continual bliss, as the satirists of the period were quick to point out. Cuckolded husbands, wife-selling and wife-beating are common subjects in eighteenth-century social satires. Another favourite theme was that of disillusionment very soon — sometimes just three weeks — after marriage. A particularly poignant print on this theme is *The Return from Scotland, or Three Weeks after Marriage* of 1777 (PD 1877,1013.876; BM Satires 4625), in which a puzzled husband stares at his wife's back while she holds a book and gazes downwards mournfully, as if regretting her haste in marrying. A lute lies discarded on the floor, a sad memory of happier times.

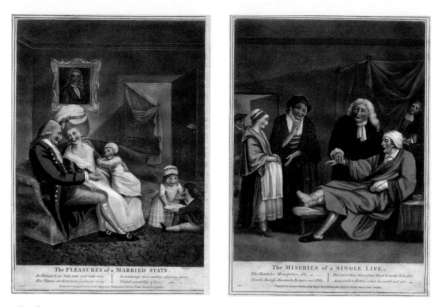

The Pleasures of a Married State (left) and *The Miseries of a Single Life* (right).
Published by Carington Bowles. Hand-coloured mezzotints, *c.* 1774

Many of the prints featured in this book are mezzotint drolls or 'posture' prints, so called because they were a particular size (36 x 25.4 cm) and could be easily fitted into frames of a standard size. A droll was a non-political print that demonstrated a social situation to comic effect. The moralizing messages of these prints were conveyed through objects whose symbolism was immediately recognizable to a contemporary audience that spanned the aristocracy to the lower classes; allusions were taken from a variety of sources ranging from classical mythology to popular culture.

The main publisher of these prints was the London-based Carington Bowles (1724–93, subsequently Bowles and Carver), who sold them from his print shop in St Paul's Churchyard and from the associated premises of his

uncle John Bowles in Cornhill. The 'posture' prints published by Carington Bowles were often after designs by John Collet and, following Collet's death, Robert Dighton. The two artists were heirs to the comic and moral tradition that began with William Hogarth, who dominated the scene from the 1720s to his death in 1764.

It was Thomas Rowlandson and James Gillray who ushered in – according to the historian Dorothy George – 'the golden age of caricature', which lasted approximately from the 1780s to the 1800s. They favoured etching rather than mezzotint as their medium. Etchings could be produced quickly, which allowed their work to be almost contemporary with the events they are lampooning, and their prints could be bought in highly coloured impressions.

Who was the audience for prints such as these? Many were aimed at collectors and were put into portfolios or bound volumes for private consumption. Others were displayed pasted on to folding screens or on the walls of special rooms in fashionable houses. In public they appeared not only in print-shop windows, but also on street corners or in ale houses or gin shops. A gentleman could also hire out a portfolio for an evening's entertainment, rather like a print-lending library.

The prints were usually sold at a price of one shilling for a plain impression or two shillings for a coloured one. The latter were specially worked on by hired colourists, usually with thick gouache paints, and were particularly eye-catching when displayed in a print-shop window. Dorothy George called the print-shop windows 'the picture galleries of the public'; the eagerness with which the latest piece of juicy gossip was lapped up by the contemporary audience relatively soon after the event shows that our current fascination with scandal and celebrity is nothing new.

COURTSHIP

To the contemporary eye, this print – one of a set of four representing the seasons – evokes all that is beautiful about young love in Spring, the time of year traditionally associated with courtship since medieval times.

A youth points out two doves to his sweetheart; beside him a boy plays with a bird's nest and an old woman looks on crossly. In the foreground a magpie delves into a basket full of eggs, reminding the viewer of the bird's traditional associations with bad luck and providing a counterpoint to the two doves, which symbolize concord and conjugal affection.

John Collet (c. 1725–80) was a painter and draughtsman in the tradition of Hogarth, producing works of a highly moralizing yet humorous nature. Many of the unsigned 'posture' mezzotints issued by Carington Bowles were after designs by Collet and were inscribed 'From the Original Picture by John Collet in the possession of Carington Bowles'.

Spring
After John Collet; published by Carington Bowles
Hand-coloured mezzotint, c. 1778–9

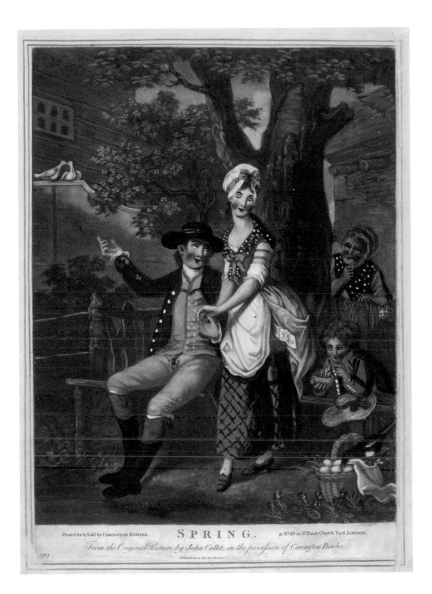

THIS CHARMING PRINT shows a scene of flirtation taking place in a milliner's shop. Two men try to entice the three attractive milliners to a masquerade ball. One man leans provocatively over the counter, the other hands a 'masquerade ticket' to one of the women. Masquerades were commercially mounted masked balls staged at various theatres or pleasure gardens throughout the capital and were associated with illicit amorous assignations. Milliners were reputed to have loose sexual morals, provoking the contemporary commentator Robert Campbell to denounce them as 'enemies to conjugal affection, [they] promote nothing but vice and live by lust' (*The London Tradesman*, 1747). To reinforce the point, the Pomeranian dog in the foreground would have symbolized carnal desire to the eighteenth-century viewer, as dogs were often used to represent the baser urges in the moralizing seventeenth-century Dutch genre paintings that were popular at the time.

The artist Robert Dighton (1751–1814) worked chiefly for Carington Bowles after the death of John Collet in 1780. A talented singer, Dighton appeared at Sadler's Wells in the 1790s. His work is charming and proved to be very amusing to a contemporary audience. However, when times became hard for the artist in the 1800s, he took to stealing works from the British Museum, including many of Rembrandt's prints, stamping them with his own collector's mark. The prints were later recovered.

A Morning Ramble, or — The Milliners Shop
After Robert Dighton; published by Carington Bowles
Hand-coloured mezzotint, 1782

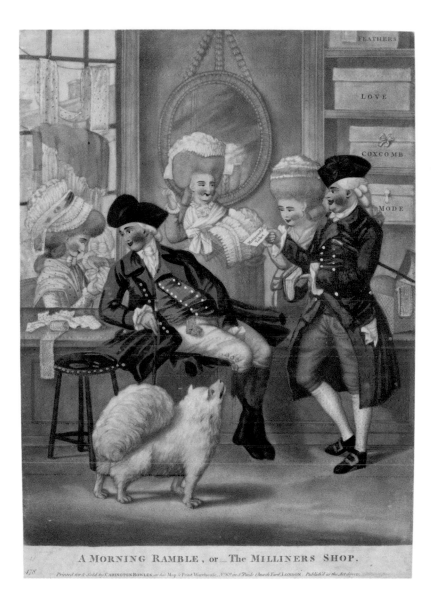

FEATHERS

LOVE

COXCOMB

MODE

A MORNING RAMBLE, or ─ The MILLINERS SHOP.

Printed for & Sold by CARINGTON BOWLES, at his Map & Print Warehouse, N°69 in St Pauls Church Yard LONDON . Publish'd as the Act directs.

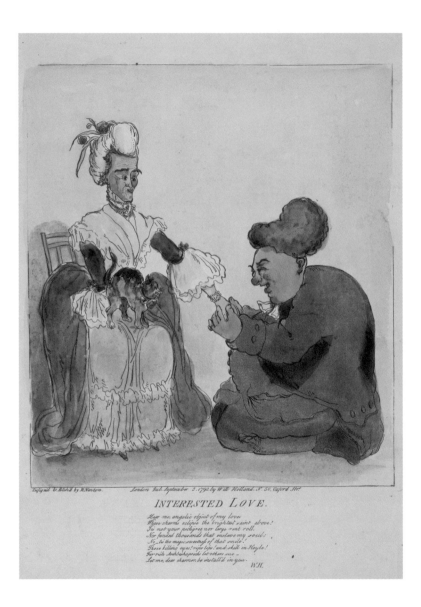

Design'd & Etch'd by R.Newton. London Pub. September 5.1793.by Will: Holland. N° 50. Oxford St.

INTERESTED LOVE.

Hear me angelic object of my love,
Whose charms eclipse the brightest saint above!
Tis not your pedigree nor large rent roll,
Nor funded thousands that inslave my soul:
No—tis the magic sweetness of that smile!
Those killing eyes! ruby lips! and skill in Hoyle!
Far richer Arch-bishopricks let others owe —
Let me, dear charmer, be install'd in you.

W.H.

14

IN THIS PENDANT to an earlier print, *Disinterested Love* of 1790, a large clergyman kneels before his intended, professing his love for her. Despite her incredible wealth, he claims that he desires her only for her physical attractions. The tongue-in-cheek nature of the print is perfectly conveyed by the verse printed beneath the image (Hoyle refers to a book of card game rules):

> Hear me angelic object of my love
> Whose charms eclipse the brightest saint above!
> Tis not your pedigree nor large rent roll
> Nor funded thousands that enslave my soul;
> No tis the magic sweetness of that smile!
> Those killing eyes! ripe lips! And skill in Hoyle
> For rich Archbishopricks let others sue —
> Let me, dear charmer, be installed in you

Richard Newton (1777–98) specialized in producing outrageously bawdy prints with his signature style of exaggerated expressions, though he was also capable of a remarkable delicacy and fluidity of line. This print and its pendant appear in his watercolour of the exhibition rooms in William Holland's print-shop (PD 1876,0510.764). Holland was Newton's publisher until 1797. He died at the tragically young age of twenty-one, but in his short life he managed to produce a staggering three hundred prints.

Interested Love
Richard Newton; published by William Holland
Hand-coloured etching, 1793

Newton's goggle-eyed couple gaze at each other in eager anticipation, echoing the words of a love poem by Ben Jonson (1572–1637) entitled *To Celia*:

> Drink to me only with thine eyes
> And I will pledge thee mine;
> Or leave a kiss within the cup
> And I'll not ask for wine.
> The thirst that from the soul doth rise,
> Doth crave a drink divine;
> But might I of Jove's nectar sup,
> I would not change for thine.

The poem was set to music in the eighteenth century and became a popular song some time after 1770.

Newton set himself up as an independent publisher in March 1797. This work, however, was among four printed that year by his previous publisher, William Holland.

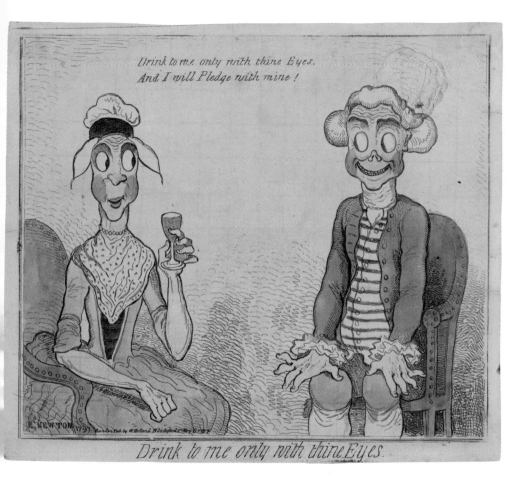

Drink to me only with thine Eyes
Richard Newton; published by William Holland
Hand-coloured etching, 1797

DISAPPOINTED LOVE

Four compartments depict the progress – or decline – of a relationship between the rich widow Mrs Griskin and the poor Jerry Thimble. Each compartment is labelled as one of the four seasons: Spring is again associated with courtship and Summer with a happy marriage. However, by Autumn things are turning sour, with both parties accusing the other of infidelity and wanting a separation. Winter sees them with a lawyer, both now much happier apart.

Thomas Rowlandson (1757–1827) was one of the foremost caricaturists of the age. He excelled in revealing the absurdities of everyday life, emphasizing the foolishness and frailty of human nature. Rowlandson studied at the Royal Academy Schools, producing numerous political and social caricatures. By the 1790s he had gambled away a legacy left to him by his aunt and was desperate to make some money. He worked tirelessly for the publisher Rudolph Ackermann and for Thomas Tegg who, unlike Ackermann, catered for the lower end of the market.

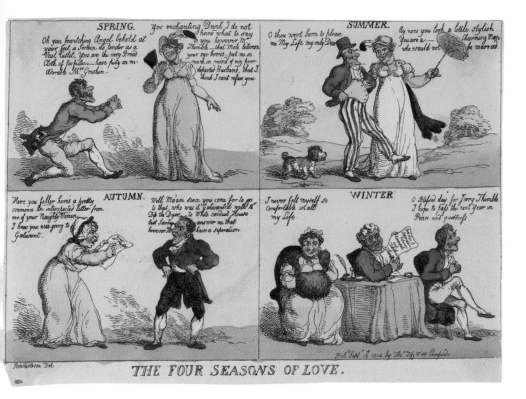

The Four Seasons of Love
Thomas Rowlandson; published by Thomas Tegg
Hand-coloured etching, 1814

IN THIS richly decorated print a beautifully dressed but tearful girl is led towards an elderly man holding a crutch, possibly a prospective suitor or husband. The older woman, either her mother or a procuress (brothel keeper), is sacrificing the girl into the man's clutches. Numerous symbols warn the viewer that this is a wretched situation; for example, a book of poems by the famous rake and poet the Earl of Rochester (1647–80) lies on the floor, open at a page that reads fatefully, 'This bud of Beauty, other Years demand, Nor should be gather'd by such withered hands'. The bottle of viper wine visible in the foreground was a tonic traditionally used by seducers as an aphrodisiac. Scenes such as this were very popular in seventeenth-century Dutch genre paintings, and usually featured a procuress showing off her latest acquisition to a prospective client.

The Victim
After John Collet; published by Carington Bowles
Hand-coloured mezzotint, 1780

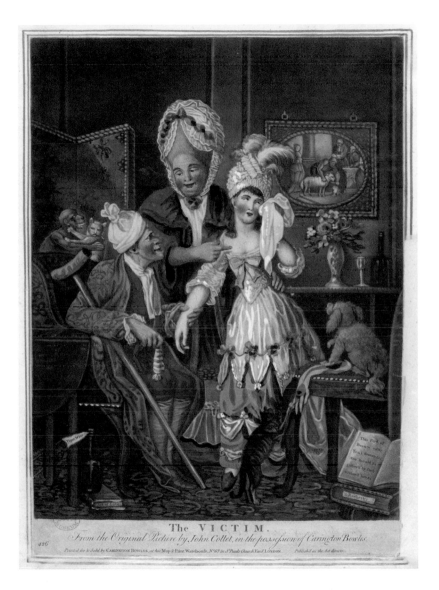

The VICTIM.

From the Original Picture by John Collet, in the possession of Carington Bowles.

426 Printed for & Sold by CARINGTON BOWLES, at his Map & Print Warehouse, N.º 69 in St Pauls Church Yard LONDON. Published as the Act directs.

21

THE TITLE and inscription of this print are taken from Shakespeare's *Twelfth Night* (Act II, scene iv), when Viola tells the duke a tale of unrequited love. This lofty literary reference is used here to illustrate the pitiful plight of a poor, ugly apple seller:

> She never told her love!
> But let concealment like a worm i' the bud
> Feed on her damask cheek

What exactly is she concealing? Perhaps a bottle beneath her petticoats, or the fact that she has yielded to temptation, has been rejected by her lover and may be pregnant? Eighteenth-century society drew a line between virtuous and non-virtuous sexual conduct in women of every class. This poor unfortunate is liable to become an outcast, paying a high price for her lapse into temptation.

George Cruikshank (1792–1878) was a natural heir to James Gillray, specializing in prints of a strange and fantastical nature. This undated print is rather unusual in his *œuvre*.

'She never told her love!'
George Cruikshank
Hand-coloured etching, n.d.

"She never told her Love!"
"but let concealment like a worm i' the bud"
— *"feed on her damask cheek."* —

THE TRAGIC NARRATIVE of this print is explained by the extensive text beneath the image, which describes how to hang oneself, this being the rather extreme cure for the protagonist's amorous misadventure. In a speech bubble he bewails his love's falsehood; her rejection is made clear from a letter lying on the floor: 'You old fool if you ever [?trouble] me again with your stupid epistles I will expose you in the Public Papers. Peggy Perkins.'

It is unusual to find a depiction of a man disappointed in love, as men seemed to hold all the advantages when courting, and indeed in marriage. However, Englishmen around this period had a reputation for committing suicide, which was noted by foreign visitors. For example, a print of 1814, *Amusements des Anglais à Londres* by Alphonse Roehn (PD 1861,1012.326, BM Satires 12353), shows three Englishmen committing suicide by hanging, shooting and drinking, while a fourth reads Edward Young's poem *Night Thoughts*.

A cure for love
Published by S.W. Fores
Hand-coloured etching, 1819

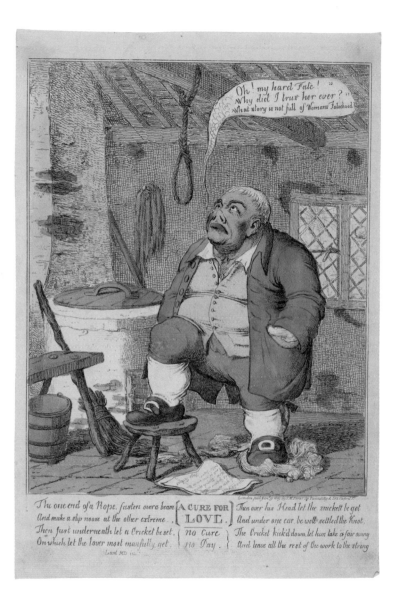

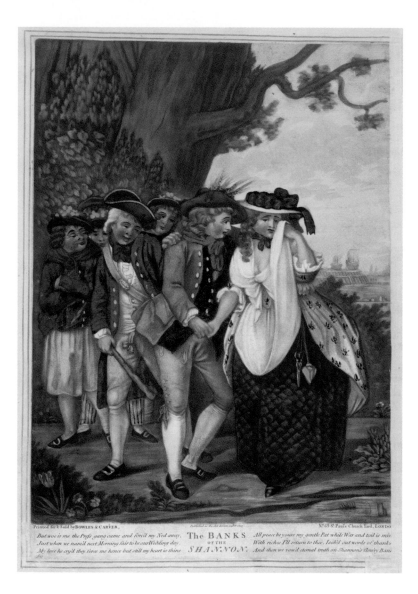

Printed for & Sold by BOWLES & CARVER,

Published as the Act directs 24 Feb. 1791

N.º 69 S.ᵗ Paul's Church Yard, LONDO

But woe is me the Press gang came and forc'd my Ned away.
Just when we nam'd next Morning fair to be our Wedding day.
My love he cry'd they force me hence but still my heart is thine

The BANKS
OF THE
SHANNON.

All peace be yours my gentle Pat while War and toil is min
With riches I'll return to thee. I sob'd out words of thanks
And then we vow'd eternal truth on Shannon's flowry Ban

IN THIS PRINT the unhappy couple, Pat and Ned, are about to be separated the day before their wedding by a press gang, which waits behind them to take the young man to forcibly join the navy. The scene takes place on the banks of the river Shannon: Irish men formed a huge part of the Royal Navy at this time when Britain was at war with France.

Press gangs were rife in the eighteenth century and were a legal way of recruiting men for service in the navy or the army. As the navy could not rely on volunteers to form full crews on board ships, press gangs were used to grab men against their will to fight for their country. From 1740 only men between the ages of eighteen and fifty-five could be taken and their service was limited to five years.

The Banks of the Shannon
After Robert Dighton; published by Bowles & Carver
Hand-coloured mezzotint, 1799

THIS CRUEL PRINT by James Gillray (1756–1815) shows Emma Hamilton in a parody of one of her famous 'attitudes', in which she posed as various characters from classical mythology. Here she is depicted lamenting the departure of Lord Nelson's fleet, echoing the plight of Dido, the mythical queen of Carthage who was abandoned by Aeneas, as described in Virgil's *Aeneid*. Gillray depicts Hamilton as enormously plump, though she was seven months pregnant when this print was issued, in great contrast to the sylph-like creature who was Nelson's lover. Her husband, the famous collector Sir William Hamilton, lies in bed in sleepy oblivion. On the floor are scattered phallic statuettes from Hamilton's collection.

Emma Hamilton (née Hart, 1765–1815) was one of the great beauties of her day. Abandoned by her lover, the Hon. Charles Francis Greville, she was passed on to his uncle, Sir William Hamilton, British Envoy to Naples, and married him in 1791. It was in Naples that Emma met Horatio Nelson in 1798 and began an affair that made Sir William one of the most famous cuckolds of the period and a great butt of the caricaturists.

Gillray, along with Thomas Rowlandson, represented the 'golden age' of caricature in Britain. He excelled in lampooning everyone from royalty to politicians, and took great liberties in his work, relishing each scandal with his pen. His great talent was in the grotesque characterization of his subjects and his wicked sense of humour. Gillray worked for several publishers, including William Holland, until 1791, from which date he worked almost exclusively with the printseller and publisher Hannah Humphrey until his death.

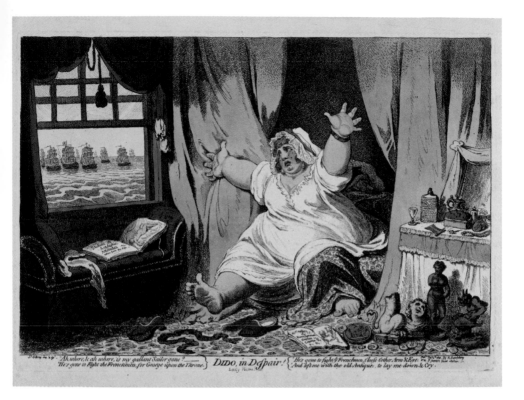

Dido, in Despair!
James Gillray; published by Hannah Humphrey
Hand-coloured etching, 1801

TEMPTATION

A COURTESAN SITS outside and points at herself as a commodity on offer, enticing the viewer with this provocative gesture. She is richly dressed, with a fashionable hat, and sits cross-legged on a curious carved seat ornamented with a satyr's mask.

Prostitutes were common in eighteenth-century London and feature heavily in caricatures of the period. One popular work compared a low-life individual found in the slums of St Giles, a notoriously poor part of town with a reputation for danger and licentiousness, with a beauty from the upmarket streets of an area in west London such as St James, possibly the patch of the prostitute seen here. It has been suggested that the quotation from Proverbs printed beneath the image could indicate that such prints are in fact satirizing the moralizing texts of conduct literature aimed at young women. They point to, among other things, modesty in dress as this shows virtue, unlike the prostitute who is dressed in luxurious finery of the highest fashion.

The print is from a group of mezzotints depicting prostitutes based on drawings by John Raphael Smith (1751–1812). The series, entitled 'Ladies in fashionable Dresses and enchanting Attitudes', dates from 1776–81 and was published by Bowles. The drawing for this print, entitled *The Charmer*, is in the Paul Mellon Collection at the Yale Center for British Art in New Haven.

A Foolish Woman
John Raphael Smith; published by Carington Bowles
Hand-coloured mezzotint, 1780

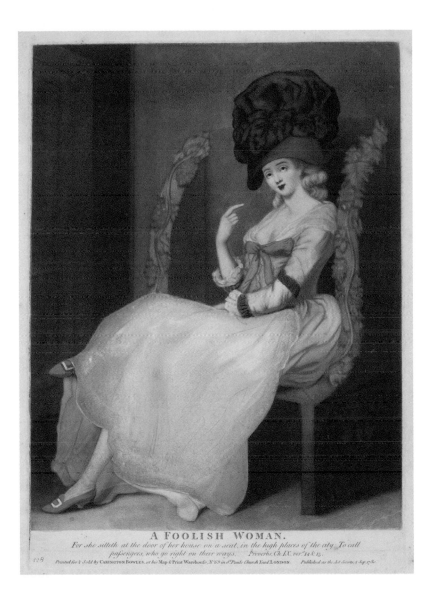

A FOOLISH WOMAN.

For she sitteth at the door of her house on a seat, in the high places of the city, To call
passengers, who go right on their ways. Proverbs, Ch. IX. ver. 14 & 15.

528 Printed for & Sold by CARINGTON BOWLES, at his Map & Print Warehouse, No 69 in St Pauls Church Yard, LONDON. Published as the Act directs, 1 Sep. 1781.

THIS PRINT shows a couple at a masquerade, an event laden with temptation, as documented in a pamphlet of 1721, which describes a masquerade as 'an open scene of Outrageous and flaming Debauchery, where Temptation is passionately courted, the wanton Imagination indulged to the last degree, so that none who go there return from thence chaste and innocent. The most virtuous and resolute Mind is by degrees softened, and at last dissolved into Sensuality: these are the common and sad Effects of the amorous Intrigues and luscious Indecencies usually practis'd by Masqueraders' (Anon., 'The Conduct of the Stage Consider'd with short Remarks upon the Original and Pernicious Consequences of Masquerade', 1721).

The hapless man in this print has removed his mask as he is so taken with his partner; she, however, keeps her mask on and gazes out knowingly at the viewer. The anonymity afforded by the mask allows the woman a unique freedom, no doubt eliciting the disapproval of the anonymous moralist quoted above, who goes on to warn anyone unfortunate enough to attend a masquerade of such loose women: 'by the Signs that the Sexes hang out you may know their qualities or Occupations and not mistake in making your Addresses . . . a whore [is known] by a Vizor-Mask; and a Fool by talking to her.'

Wantonness Mask'd
Published by Carington Bowles
Hand-coloured mezzotint, *c.* 1770

32

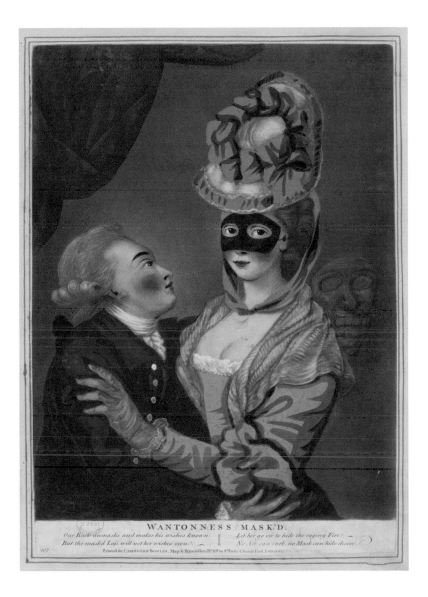

WANTONNESS MASK'D.

Our Buck unmasks and makes his wishes known. *Let her go on to hide the raging Fire.*
But the mask'd Lass will not her wishes own. *No Art can curl, no Mask can hide desire.*

207 Printed for CARINGTON BOWLES, Map & Printseller, N.º 69 in St Pauls Church Yard, LONDON.

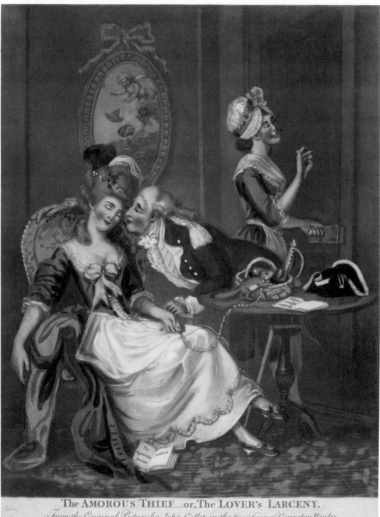

The AMOROUS THIEF ____ or, The LOVER's LARCENY.

From the Original Picture by John Collet, in the possession of Carington Bowles.

366 Printed for & Sold by Carington Bowles, at his Map & Print Warehouse, N.º 69 in S.t Pauls Church Yard London. Published as the Act directs.

A WILY YOUNG servant girl ostentatiously admires the ring with which a soldier has bribed her to admit him into the house; he proceeds to seduce the sleeping maiden slumped in a chair. A book she has been reading, *The Agreable dream realised*, alerts us that she is almost complicit in the scene.

The seduced maiden was a stock theme of eighteenth-century prints, literature and popular culture. Before her seduction she conformed to the ideal of eighteenth-century womanhood, being submissive, simple, trustful and affectionate. However, if she succumbed to her seducer she would face ostracism from good society and utter disgrace. In general sex outside marriage was considered acceptable for a man, but under no circumstances could it be sanctioned for a woman.

The Amorous Thief — or, The Lover's Larceny
After John Collet; published by Carington Bowles
Hand-coloured mezzotint, 1777

A PRETTY OYSTER SELLER entices a young gentleman to buy her wares. Oysters were cheap in eighteenth-century London and were enjoyed by all classes. They had long been considered an aphrodisiac and often featured in seventeenth-century Dutch genre paintings, especially in scenes of seduction.

'Milton [or Melton] Oysters' was a song in the repertory of the London tea gardens sung by the actress Mrs Jordan (1761–1816):

> There was a clever Lass
> Just come down from Gloucester;
> And she did get her livelihood
> By crying Milton Oysters

Molly Milton, the Pretty Oyster Woman
After Robert Dighton; published by Carington Bowles
Hand-coloured mezzotint, *c.* 1787

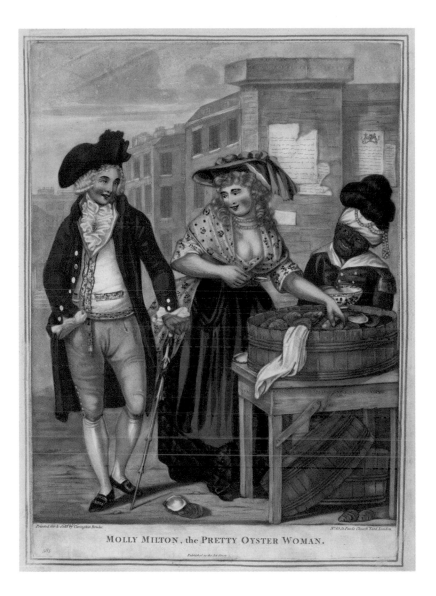

Printed, Col.st & Sold by Carington Bowles.

N.º 69. St Pauls Church Yard, London.

MOLLY MILTON, the PRETTY OYSTER WOMAN.

1585

Published as the Act directs

THE VERSE BENEATH the image in this print hints at the danger lurking if Betsey continues to be charmed by Billy. She is innocently letting him thread her needle, an explicit reference to sex that would have been obvious to an eighteenth-century audience, coupled with the fact that a seamstress was often depicted as virtuous and industrious, making her open to temptation.

Danger
Published by Bowles & Carver
Hand-coloured mezzotint, *c.* 1770

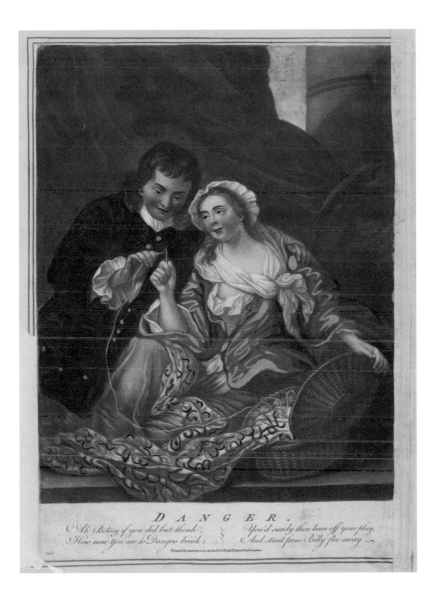

DANGER.

Ah Betsey if you did but think, You'd surely then leave off your play,
How near you are to Dangers brink; And strait from Billy flee away.

166

Printed for BOWLES & CARVER, No 69 S.t Paul's Church Yard London.

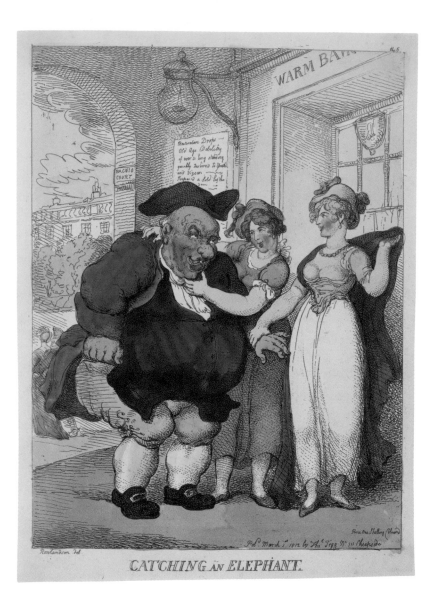

WARM BATH

CATCHING an ELEPHANT.

Two PROSTITUTES ensnare a man of elephantine proportions, presumably intending to lure him into the 'warm bagnio' behind. A 'bagnio' (Italian for 'bathhouse') was a brothel; on the wall is a notice that promises 'Restorative Drops — Old Age debility of ever so long standing quickly restored to Youth and Vigour'. The arcade visible behind the prostitutes' willing victim could indicate that this bagnio was situated in Covent Garden, an area renowned for brothels at the time. Rowlandson enjoys the playful contrast between the seductive buxom females and the hideous, expectant old man.

Catching an elephant
Thomas Rowlandson; published by Thomas Tegg
Hand-coloured etching, 1812

A N AMOROUS COUPLE attempt to steal a secret kiss away from the prying eyes of their respective elderly relatives. A man – possibly the girl's father – raises a warning finger and the ancient crone's face is distorted in anger at the thought of her handsome young charge being lured away by the charms of the beauty next door.

This print demonstrates Rowlandson's obsession with opposites and is a perfect example of pictorial symmetry, for example, age versus youth and beauty versus ugliness. The harmony of the lovers is pitched against the general discord of the animals beneath them and, as if to labour the point, two love birds, billing and cooing above their heads, are in direct opposition to the cock that impregnates a hen beneath them.

Neighbourly Refreshment
Thomas Rowlandson; published by Thomas Tegg
Hand-coloured etching, 1815

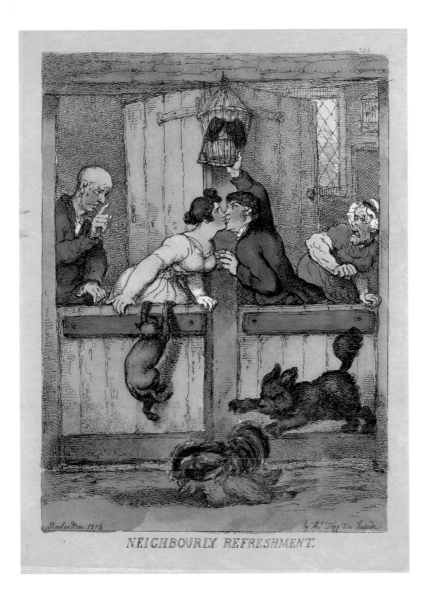

NEIGHBOURLY REFRESHMENT.

IN THE EIGHTEENTH century doctors were seen as little more than charlatans and were associated in the public consciousness with death and money. Here the physician takes the pulse of a woman on the verge of death, her unfortunate situation being precipitated by the very man who is supposed to aid her recovery. He, however, is more interested in the beautiful woman behind his patient's back. The drugs on the table (a bowl of 'Composing Draught' and some opium) give us a clue as to the outcome of his medical administrations.

Medical dispatch, or Doctor Doubledose killing two birds with one stone
Thomas Rowlandson; published by Thomas Tegg
Hand-coloured etching, 1810

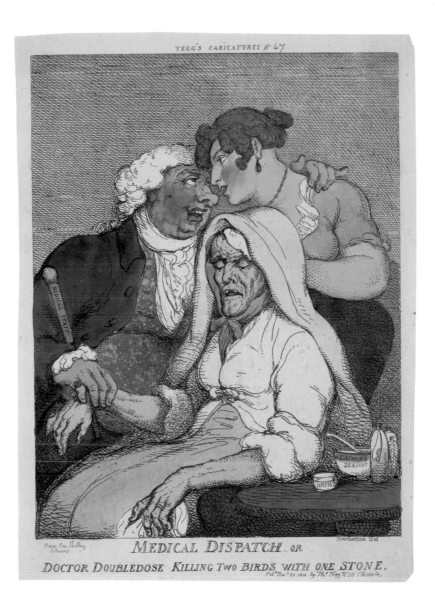

MEDICAL DISPATCH. OR
DOCTOR DOUBLEDOSE KILLING TWO BIRDS WITH ONE STONE.

45

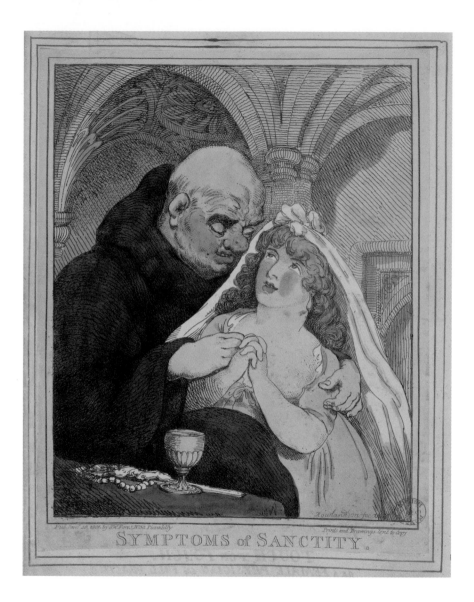

SYMPTOMS of SANCTITY.

A REPULSIVE obese monk embraces a beautiful woman whose eyes are raised heavenwards. She wears a veil, intended to show that she is a nun. The arches in the background indicate that these erotic antics are taking place in a church; in front of the couple lie the accoutrements of a Catholic monk: a chalice, a crucifix and rosary beads.

Temptations of the flesh were commonly depicted for the purposes of anti-papist propaganda. For example, in the print *Provision for the clergy* (1774; PD 1935,0522.1.213, BM Satires 3777), a monk carries a basket of provisions and has a huge sheaf of corn on his back in which a woman is concealed; and in *Father Paul and the blue-eyed nun of St Catherine's* (PD 1935,0522.1.216, BM Satires 3780), a lusty monk embraces an attractive nun who clutches a crucifix. Praying is the last thing on his mind, as the verse beneath testifies: 'The Lady of Loretto's Image by/ Is disregarded by the Father's Eye/ For if his Eye is rightly understood/ He seems to like substantial flesh and blood.'

Symptoms of Sanctity
Thomas Rowlandson; published by S.W. Fores
Hand-coloured etching, 1801

THE TITLE and subject are a crude pun on Henry Mackenzie's popular novel *The Man of Feeling* (1771), which was the archetypal sentimental novel, designed to elicit an emotional response from the reader. A true man of feeling, as described by Mackenzie, was full of virtue and sensitivity. Rowlandson delights in subverting this sentiment into pure carnal lust. The leering, lecherous parson gropes his female companion, who nonchalantly warms her toes by the fireside. Behind them is a table laden with drink. Scholarly volumes litter the floor, among them one by Pietro Aretino, a sixteenth-century poet and playwright renowned for his pornographic sonnets. This obvious reference to licentiousness would have been very clear to Rowlandson's audience.

A man of feeling
Thomas Rowlandson; published by Thomas Tegg
Hand-coloured etching, 1811

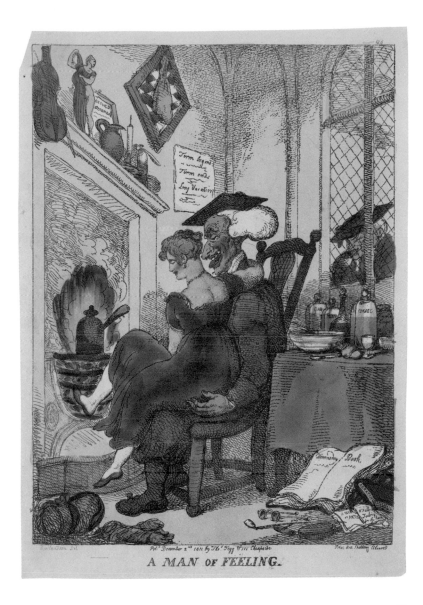

A MAN OF FEELING.

MARRIAGE

IN THIS PRINT by Hogarth, Samuel Butler's 'hero' Hudibras comes across a skimmington, which he tries to stop, calling it 'This Devil's procession'. A skimmington was an English version of the French *'charivari'*, in which an adulterous wife and her cuckolded husband — usually sitting back to back on horseback — were paraded through the streets to the accompaniment of 'rough music' such as pots and pans clanging together and raucous-sounding musical instruments. The couple were also treated to the sight of petticoats held aloft along with cuckold's horns by their mocking neighbours. The petticoat symbolized the dominance of the shrewish wife and the subordination of her husband, thereby compounding his public humiliation at not being strong enough to control his wife.

In his diaries Samuel Pepys described seeing a skimmington: 'Down to Greenwich, where I find the street full of people, there being a great riding there to-day for a man, the constable of the town whose wife beat him' (10 June 1667).

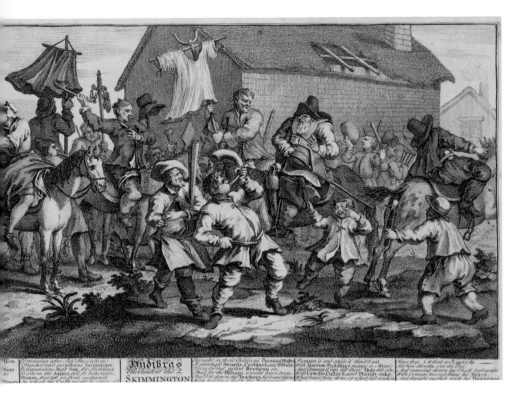

Hudibras encounters the Skimmington (plate 7 of *Hudibras*)
William Hogarth; published by Philip Overton and John Cooper
Etching and engraving, 1726

T HIS PRINT of a merry wedding party is the sequel to *A Fleet Wedding* (PD 1868,0808.3836; BM Satires 2874), in which a naive sailor and his bride are about to get married at the Rules of the Fleet, a notorious area of London where the Fleet prison, the main prison for debtors, was situated. By 1740 large numbers of weddings took place there, before the quick, cheap and clandestine nuptials characteristic of the location were made illegal by Lord Hardwicke's marriage act of 1753.

The fact that the marriage is doomed is hinted at heavily in this print. On the wall is a painting of a skimmington, not unlike that in Hogarth's *Hudibras* print; the added ships' masts refer to the sailor and his bride. A bailiff is at the door claiming an unpaid bill for the bride's gown.

This scene of London low-life owes much to the legacy of Hogarth, and indeed the overall composition is based on plate 3 of 'The Rake's Progress'.

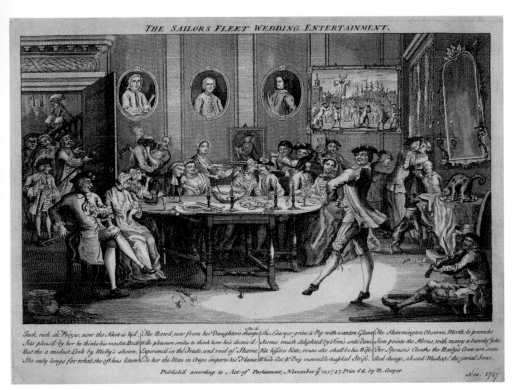

THE SAILORS FLEET WEDDING ENTERTAINMENT.

Jack, rich in Prizes, now the Knot is tyd. | The Bawd, now from her Daughters charge | The Lawyer grins, & Peg with wanton Glance | The Skimmington Observe. Mirth to provoke
Sits pleas'd by her he thinks his maiden Bride | With pleasure smiles to think how he's deceiv'd; | Seems much delighted by Tom's antic Dance, | Sam points the Horns, with many a bawdy Joke.
But tho a modest Look by Molly's shown, | Experienc'd in the Trade, and void of Shame, | He kisses Kate, vows she shall be his Wife | For Spouse's Cloaths the Bailys Crew are seen,
She only longs for what she oft has known. | To her the Man in Crape imparts his Flame. | While Cat & Dog resemble nuptial Strife. | Sad change, oh sad Mishap! the jovial Scene.

Publish'd according to Act of Parliament; November ye 10, 1747. Price 6 d. by M. Cooper

Nov. 1747

The Sailor's Fleet Wedding Entertainment
John June; published by Mary Cooper
Etching, 1747

A MAN POINTS dolefully at the padlock inscribed 'Wedlock' that dangles from a chain around his neck. He supports on his shoulders his drunken wife, who proudly holds a glass of gin in her right hand. A monkey pulls the man's hair and a magpie pecks him, both symbols of strife, as mentioned in the verse beneath. In another version of this print (of which there are several), the verse reads:

> A monkey, a magpie and wife
> Is the true Emblem of Strife
> Was 'ere Poor Man plagu'd with such evil
> I'ed steer from the Shore
> And give my whole freight to the Devil.

The image of a man carrying the burden of his wife, literally weighed down and held prisoner by matrimony, was taken from a seventeenth-century Dutch print by Daniel van den Bremden after Adriaen van de Venne.

A Man Loaded with Mischief, or Matrimony
Published by Bowles & Carver
Hand-coloured etching, *c.* 1751

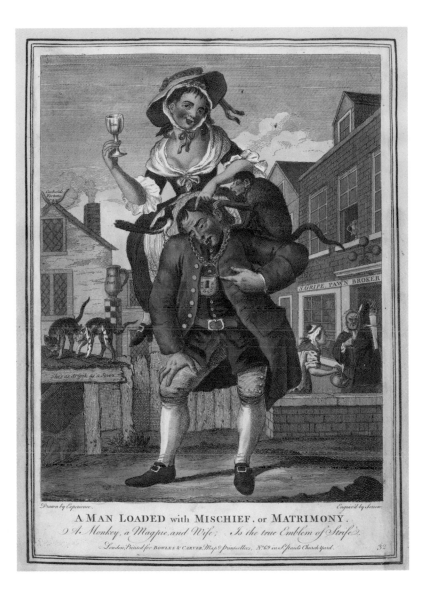

A MAN LOADED with MISCHIEF. or MATRIMONY.

A Monkey, a Magpie, and Wife; Is the true Emblem of Strife.

London, Printed for BOWLES & CARVER Map & Printsellers, Nº 69 in Sᵗ Pauls Church Yard.

Drawn by Experience.

Engraved by Senior.

32

A WOMAN TURNS AWAY in distaste as she is presented with a potential suitor. Arranged marriages for financial reasons were common in the eighteenth century, especially among the upper classes, but from the late seventeenth century the view began to emerge that mutual affection was essential in a marriage and that children should not be seen as a commodity of their parents.

The First Interview, or Happiness Sacrifised to Riches
After Robert Dighton; published by Carington Bowles
Hand-coloured mezzotint, 1784

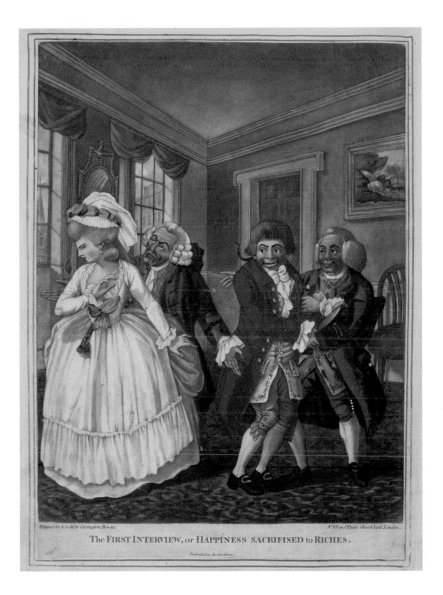

The FIRST INTERVIEW, or HAPPINESS SACRIFISED to RICHES.

I N THIS PRINT the unwilling bridegroom has to be pushed towards the altar to take his place in the marriage ceremony. His future wife has a rather large stomach, indicative of her pregnant state. Unmarried pregnant young women were looked upon with great disapproval by the parish elders, not only in the moral sense but also from a financial point of view, for the parish would have to support the mother and her illegitimate child if the father was not found. Therefore errant fathers were pursued and threatened with jail if they did not fulfil their duty and marry their unfortunate partners.

The Unwilling Bridegroom, or Forc'd Meat will never digest
Published by William Humphrey
Hand-coloured mezzotint, 1778

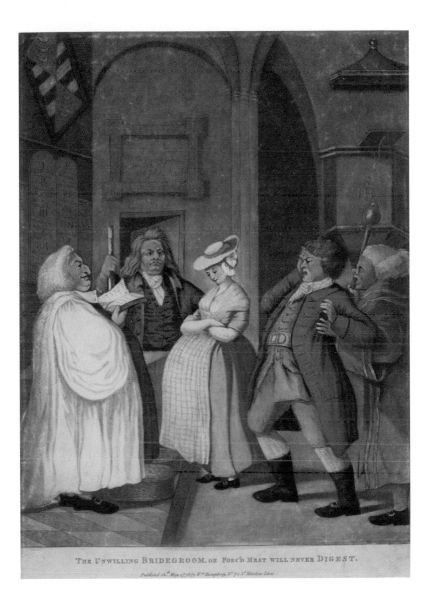

THE UNWILLING BRIDEGROOM, OR FORC'D MEAT WILL NEVER DIGEST.

Published the Mar.1772 by W.m Humphrey N.o 70. S.t Martins Lane.

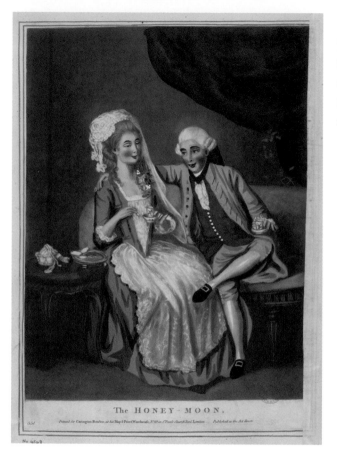

The Honey-Moon
Published by
Carington Bowles.
Hand-coloured
mezzotint, 1777

The HONEY-MOON.

Printed for Carington Bowles, at his Map & Print Warehouse, N°69 in St Paul's Church Yard, London. Published as the Act directs.

No 4508

MARITAL HARMONY swiftly followed by disillusionment was a popular subject for caricaturists, and is perfectly exemplified by these two charming prints. In *The Honey-moon* the couple daintily hold coffee cups and seem in close harmony with each other. In *Six weeks after*

Six weeks after
Marriage
Published by
Carington Bowles.
Hand-coloured
mezzotint, 1777

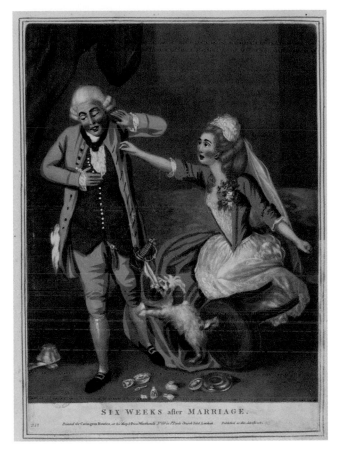

SIX WEEKS after MARRIAGE.

Marriage the scene is one of complete disarray. The table has been upset and the coffee cups flung to the ground. The husband, instead of looking tenderly at his wife as in the previous print, is now shielding himself from her attack.

IN THIS COMPLETELY fabricated scene, the Prince of Wales marries Mrs Fitzherbert abroad in a large Catholic church with images of temptation displayed on the walls. In fact the couple married not in church but at her house in Park Street on 15 December 1785. Because the king had not given his consent, the prince had contravened the Royal Marriage Act of 1772, and so the marriage was illegal. Also, under the Act of Settlement of 1701, anyone married to a Roman Catholic was excluded from the succession to the throne. The marriage was a boon to caricaturists and the controversy surrounding it generated many prints.

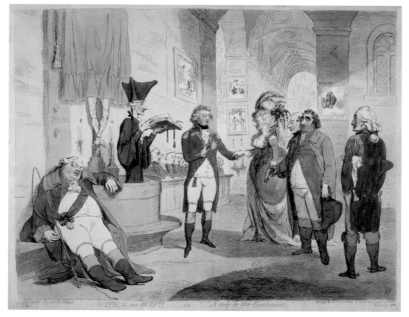

Wife & no wife — or — A trip to the Continent
James Gillray; published by William Holland. Hand-coloured etching, 1786

THE PENDANT print shows another imagined scene, this time set in the bedroom of a French inn. A voluptuous Mrs Fitzherbert is seen coaxing the yawning prince back into bed. Gillray has drawn the protagonists with great delicacy and the scene is one of pretend 'reportage' rather than grotesque caricature. The posture of the prince echoes that of the wife in plate 2 of Hogarth's *Marriage a la Mode*, a reference that would have been obvious to Gillray's audience. Gillray enjoyed depicting the debauched lifestyle and sexual excesses of the prince and here uses the absurd pseudonym 'Plenipo Georgy' to reflect the narrative.

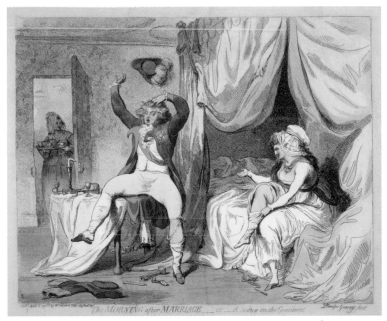

The Morning after Marriage — or — A scene on the Continent
James Gillray; published by William Holland. Hand-coloured etching, 1788

F REDERICK, DUKE OF YORK (1763–1827), brother of the Prince of Wales, had married Frederica, the eldest daughter of the King of Prussia, in 1791. Much press attention was focused on the size of the duchess's tiny feet. Ladies' feet were much admired in the eighteenth century and those of the duchess caused a sensation as they measured just five and a half inches long. In this print Gillray suggestively sandwiches the duke's comparatively enormous feet between the tiny shoes of the duchess.

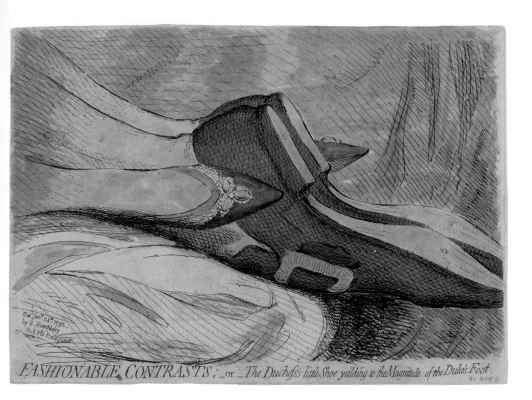

Fashionable Contrasts; — or — the duchess's little shoe
yielding to the magnitude of the duke's foot
James Gillray; published by Hannah Humphrey
Hand-coloured etching, 1792

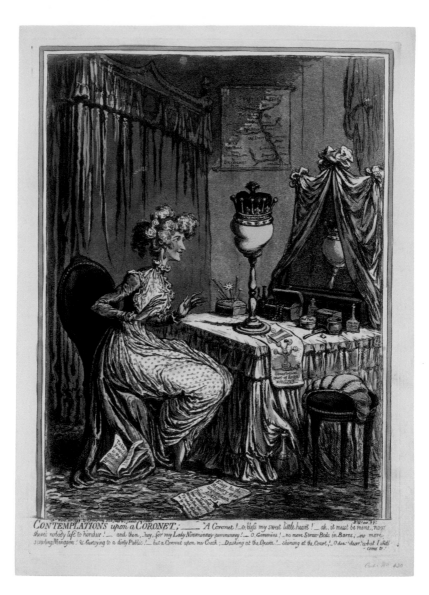

CONTEMPLATIONS upon a CORONET; ———— "A Coronet!—o bless my sweet little heart!—ah, it must be mine,—now there's nobody left to hinder it!—and then,—hey, for my Lady Nimmummey-pimmumney!—O, Gemmins!—no more Straw-Beds in Barns;—no more scowling Managers! &c curtsying to a dirty Public!—but a Coronet upon my Coach;—Dashing at the Opera!—shining at the Court!—O dear! dear! what I shall come to!"

THE ACTRESS Elizabeth Farren (1759/62–1829) is shown here eager to grasp the coronet that sits tantalizingly on the wig-stand on her dressing table. In another print, entitled *The Quality Ladder* (not in the Museum's collection), women strive to climb a spiral staircase, at the summit of which is a ducal coronet. Marrying a duke meant that one entered the highest rank of the aristocracy and thus represented the pinnacle of social climbing.

It was unfair of Gillray to emphasize the actress's desire to marry merely for status. Farren and Lord Derby (who was in fact an earl not a duke) had formed a loving attachment but had to wait for his wife to die because he refused to give her the satisfaction of a divorce: she had previously absconded with the Duke of Dorset only to be abandoned by him and return to Derby. She obliged the couple by dying on 14 March 1797 and Gillray immediately rushed this print into publication to suggest that Farren could not wait to get married.

The actress made her last appearance on stage, playing the part of Lady Teazle in Sheridan's *The School for Scandal*, on 8 April to a capacity crowd at Drury Lane Theatre. She married Lord Derby on 1 May, and the wedding was perceived by some, Gillray included, to have taken place with unseemly haste. Farren was a noted beauty and Thomas Lawrence's famous portrait of her (now in the Metropolitan Museum of Art, New York) had been exhibited at the Royal Academy the previous year.

Contemplations upon a Coronet
James Gillray; published by Hannah Humphrey
Hand-coloured etching and aquatint, 1797

RICHARD NEWTON had an admirable penchant for depicting the battle of the sexes and in this print he surveys almost every permutation of the pros and cons of marrying a particular man or woman, whether it be for their looks, wealth or status. The print is as witty as it is cruel; for example, an elderly matron eyes up a young specimen and contemplates 'a good subject for keeping up the family title, I'll have him', and a short army officer speculates on an elegant beauty much taller than himself but concedes, 'she's devilish tall, but I'll have her — she'll improve the regiment'.

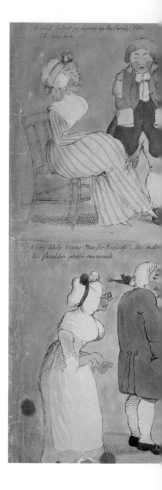

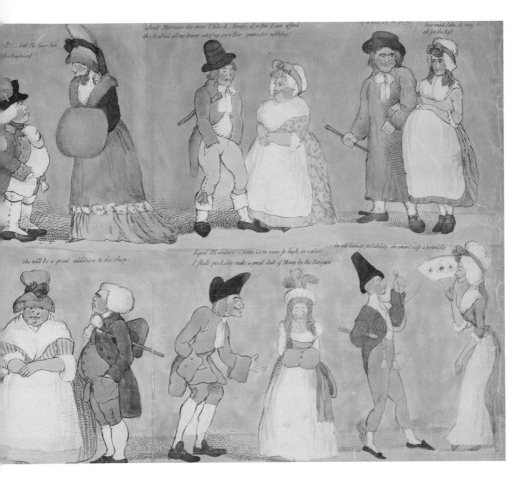

Matrimonial Speculation
Richard Newton; published by William Holland
Hand-coloured etching, 1792

ROWLANDSON's sense of the absurd is captured perfectly here as the stout prospective bride clumsily slips from a ladder while preparing to elope, crushing her future beau. An angry relative, possibly her father, peers out crossly from a window to observe her mishap. Off she goes, quite literally, to get married in Gretna Green. Hardwicke's law did not apply in Scotland and so Gretna Green, the first settlement over the border, became the favourite destination of runaway couples seeking a hasty or illicit marriage.

Off she goes
Thomas Rowlandson, after George Moutard Woodward
Published by Thomas Tegg. Hand-coloured etching, ?1812

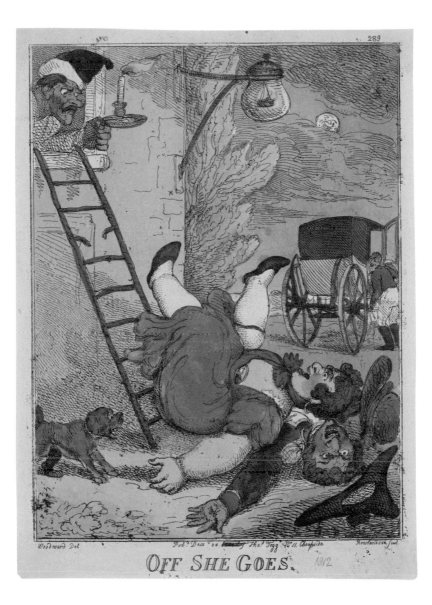

OFF SHE GOES.

THE CUCKOLD — a husband deceived by an unfaithful wife — was a favourite theme of caricaturists. The husband of the coaxing wife is placed at the centre of this print with enormous cuckold's horns seemingly projecting out of the top of his head (although they are in fact the antlers of the stag attached to the wall). His wife is cajoling him with one hand but allows the other to be kissed by her lover behind her husband's back. Many details in this print allude to the hapless husband's situation; for example, on the wall is a picture of a river with the title *An exact view of cuckold's rest*. Other pictures depict *Mars led by Cupid* and *A map of Cape Horn*. One of the dogs even sports a collar which is inscribed, as if we need reminding, 'The Revd Mr Dope'.

London Printed for R.ʃ Sayer Nº 53 Fleet Street ɩɟʰ Sm

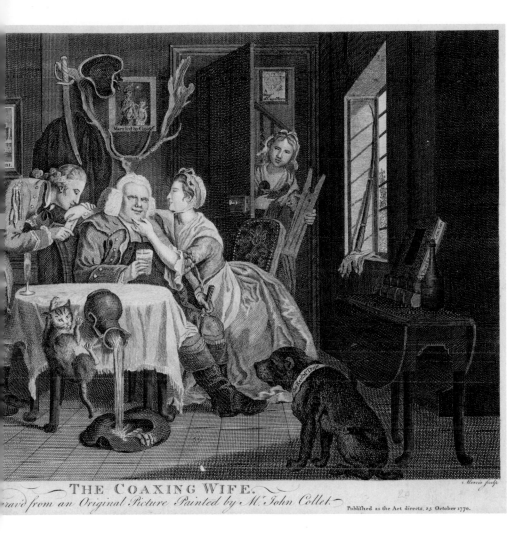

THE COAXING WIFE.

...ravd from an Original Picture Painted by Mr. John Collet.

Published as the Act directs. 25 October 1770.

The Coaxing Wife

Morris, after John Collet; published by Robert Sayer and John Smith

Etching and engraving, 1770

In THIS PRINT a wife is suspected by her husband of having an affair with her hairdresser. The husband rushes in brandishing his whip, while the cheeky maidservant gives the viewer a clue as to the cause of his rage by making the sign of horns above his head, the traditional symbol of the cuckolded husband. Eighteenth-century hairdressers, or 'frizeurs' as they were popularly known, were usually male and French. They were portrayed as ridiculous effeminate beings, the very antithesis of an upright, honest English gentleman, and deserving of a thrashing if suspected of improper behaviour towards their wives. The fashion for enormous and elaborate hairstyles for women reached a peak in the 1770s and the styles, along with their creators, were the butt of many caricaturists.

A hint to husbands, or the dresser, properly dressed
Philip Dawe; published by Sayer & Bennett
Mezzotint, 1777

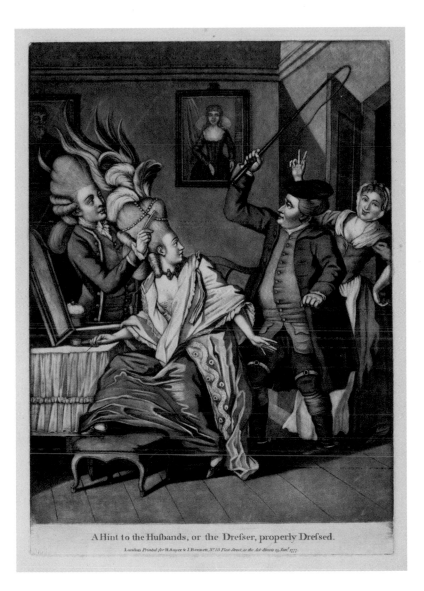

A Hint to the Husbands, or the Dresser, properly Dressed.

London Printed for R.Sayer & J.Bennett, N°.53 Fleet Street, as the Act directs 13.Jan.ʸ 1777.

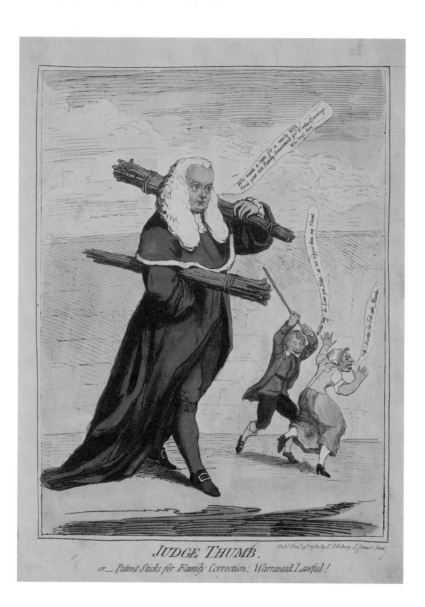

JUDGE THUMB.

or — Patent Sticks for Family Correction: Warranted Lawful !

J UDGE BULLER (1746–1800) advocated the practice of wife-beating as long as the stick used was no bigger that the husband's thumb. He is shown here clutching bundles of sticks, crying, 'Who wants a cure for a rusty wife? Here's your nice Family Amusement for Winter Evenings! Who buys here?' A contemporary observer deemed this print 'a very striking likeness of the judge'. In the background a man is about to beat his wife as she pleads, 'Help! Murder for God's sake Murder!' Her husband replies, 'Murder, hay? It's Law you Bitch! It's no bigger than my Thumb!'

To have a member of the legal establishment condone physical abuse is shocking to a modern audience. However, violence towards lower-class women was common in the eighteenth century as it was thought necessary to keep them in line.

Judge Thumb, or — patent sticks for family correction: warranted lawful!
James Gillray; published by Elizabeth Darchery
Hand-coloured etching, 1782

THE SCOLDING or quarrelsome wife was a stock character in contemporary plays, satires, ballads and sermons. They generally railed against their abusive or feckless husbands. This incessant nagging and continual emasculation drove their husbands to desperate means in order to make their wives pay. The inference in this print is that the wives deserve their punishment.

The cobbler here has had enough and sews up his wife's mouth with the tools of his trade; he has in waiting a buxom young beauty who assists him in the process by holding up a candle. His wife has been tied to a chair, with her hands secured.

The cobler's cure for a scolding wife
Thomas Rowlandson; published by Thomas Tegg
Hand-coloured etching, ?1813

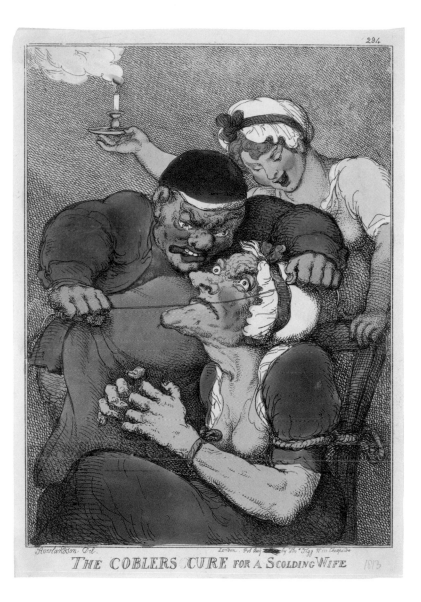

THE COBLERS CURE FOR A SCOLDING WIFE

THE DISTASTEFUL PRACTICE of wife-selling was common among the lower classes in the eighteenth century. This sort of 'divorce' usually took place in a cattle market, in this case Smithfield in London, and the wife, or 'heifer' as she is referred to in this print, was sold off to the highest bidder in the manner of a cattle auction. This unfortunate wife even wears a halter around her neck as her soon to be ex-husband announces 'I'll warrant she's Beef to the Heels'. In many cases the 'buyer' was the wife's lover. In this sense a woman was seen purely as a commodity to be purchased and sold.

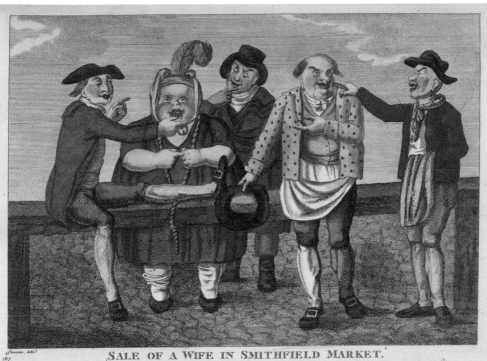

SALE OF A WIFE IN SMITHFIELD MARKET.

187

Now is your time Gemmen ; here's my Fat Heifer and ten pounds worth of bad Halfpence , all for half a Guinea , why her Hide's worth more to a Tanner, I'll warrant She's Beef to the Heels, and tho' her Horns ben't Wisible , yet he that buys her will soon feel their Sharpness. ___ there hant been such a Beast in the Market for Years____ Zounds says the Fool in the Blue Apron, I think I'll take her of thee , She, and the Halfpence , must be worth the Money, I have had two Wives, and wou'd have Sold 'em both for half that Sum .

Published 25th July 1797 by LAURIE & WHITTLE, 53 Fleet Street London.

Sale of a wife in Smithfield Market
After Mathias Finucane; published by Laurie & Whittle
Hand-coloured etching, 1797

81

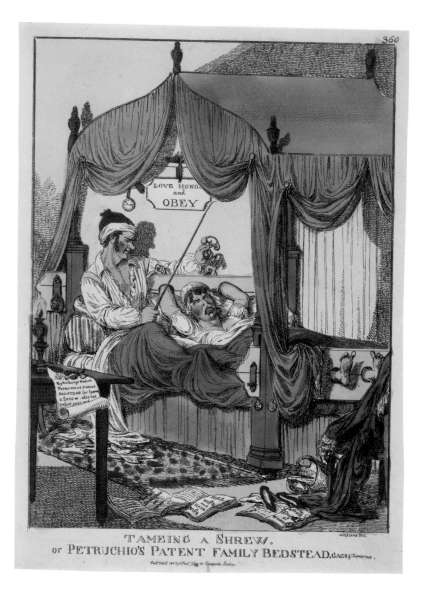

TAMEING A SHREW.
or PETRUCHIO'S PATENT FAMILY BEDSTEAD, GAGS & THUMBSCREWS.

THE POPULAR VIEW of women, especially wives, in eighteenth-century prints was that of a shrew, a woman with a violent or nagging temper. This print references Shakespeare's play *The Taming of the Shrew*, in which the protagonist Petruchio famously tames Kate. However, he does not use the cruel methods administered here. This husband has his wife in a kind of pillory securing her hands and feet and holds a whip threateningly above her body. Not only does he subjugate and humiliate his supposedly shrewish wife, but he subjects her to a level of physical violence that is really shocking to a modern-day audience: note the metal gag he is holding for her mouth and the thumbscrews on the table. The books lying on the floor, such as *Rule a Wife and Have a Wife*, reinforce the point.

Tameing a shrew, or Petruchio's patent family bedstead, gags & thumbscrews
Charles Williams; published by Thomas Tegg
Hand-coloured etching, 1815

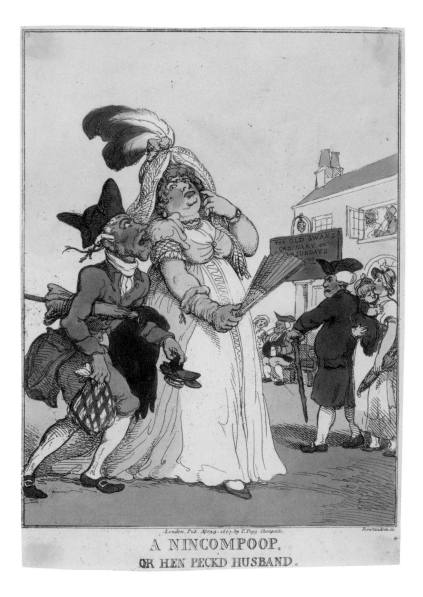

London, Pub. Apr.24. 1807. by T.Tegg, Cheapside.

Rowlandson.sc.

A NINCOMPOOP,
OR HEN PECKD HUSBAND.

THE FEEBLE HUSBAND pictured here paces behind his wife, his hands full of her belongings, and gazes up at her fearfully as she looks at him disapprovingly. Although Rowlandson shows the husband in a humiliating and subservient position, he is clearly demonstrating that the man is a figure of fun who should be despised because he has not asserted himself as master in his own marriage. This attitude is gently mocking of the male and is in sharp contrast to the misogynistic treatment of wives in some caricatures.

A Nincompoop, or hen peck'd husband
Thomas Rowlandson; published by Thomas Tegg
Hand-coloured etching, 1807

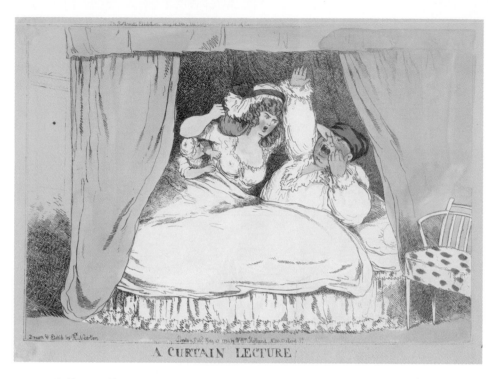

A CURTAIN LECTURE

A Curtain Lecture
Richard Newton; published by William Holland
Hand-coloured etching, 1794

THIS IS ONE of Newton's many prints depicting the battle of the sexes. It shows a man and wife with their child in bed seen through parted curtains, almost as if they were characters on a stage. She raises her fist and punches her husband's nose while furiously rebuking him. She is in fact delivering what was known as a 'curtain lecture', in which a wife nagged or complained in bed while her husband lay vulnerable to attack.

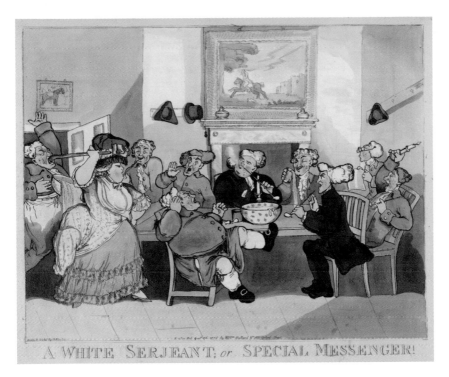

A WHITE SERJEANT; or SPECIAL MESSENGER!

The White Serjeant; or Special Messenger
Richard Newton; published by William Holland
Hand-coloured etching, 1794

Newton's marvellous scene captures the full wrath of the angry wife armed with a stick entering the tavern to fetch her errant husband home. His drinking companions look on with a mixture of astonishment and great amusement. In late eighteenth-century slang a man who was unceremoniously ejected from a tavern or alehouse by his wife was said to have been 'arrested by the white serjeant'.

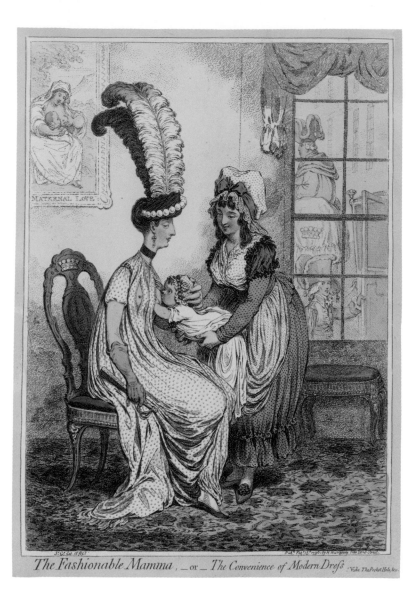

MATERNAL LOVE.

The Fashionable Mamma, _ or _ The Convenience of Modern Dress : Vide The Pocket Hole, &c.

GILLRAY HERE CONTRASTS the vogue for breastfeeding with the fashionable mother's lack of concern for her child. She deigns to let her child feed as she stares impassively and is not even roused to hold him properly, but rather leaves this to a nurse, who looks upon the child in a tender maternal way. The child is treated like a stylish accessory by the mother.

The fashion for breastfeeding derived from the doctrines of the French philosopher Jean-Jacques Rousseau (1712–78). In his book *Emile: or, on Education* (1762), he argues, 'but let mothers deign to nurse their children, morals will reform themselves, nature's sentiments will be awakened in every heart, the state will be re-peopled'.

In the first half of the eighteenth century it would have been customary for a wealthy family to employ a wet nurse, but from the latter half of the century, due to the influence of Rousseau, there was an increasing tendency for upper-class women to nurse their babies themselves, and clothes were adapted (as shown in this print) with slits at the breast to enable easy access for breastfeeding.

The fashionable mamma, — or — the convenience of modern dress
James Gillray; published by Hannah Humphrey
Hand-coloured etching and stipple, 1796

THIS IDYLLIC FAMILY SCENE shows Mr Deputy Dumpling, his wife and three children out for an afternoon at Bagnigge Wells, a popular tea garden and spa which was a favourite destination on a Sunday afternoon for middle-class Londoners.

Although this print is primarily a satirical view of the vulgarity of the mercantile classes, it nevertheless demonstrates the changing attitude towards children in the eighteenth century. During the latter half of the century childhood was beginning to be perceived as a special state of innocence, a time to be valued and nurtured, as advocated by Rousseau who stressed in *Emile* the value of childhood and parental interaction.

Mr Deputy Dumpling and family enjoying a summer afternoon
After Richard Dighton; published by Carington Bowles
Hand-coloured mezzotint, 1781

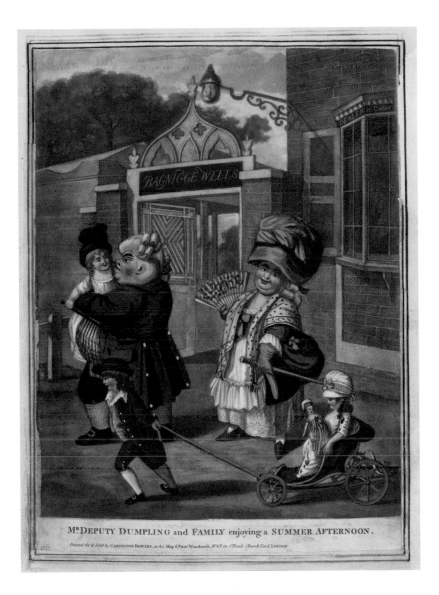

Mr. DEPUTY DUMPLING and FAMILY enjoying a SUMMER AFTERNOON.

Printed for & Sold by CARINGTON BOWLES, at his Map & Print Warehouse, N.º 69 in S.ᵗ Pauls Church Yard, LONDON

GILLRAY DELIGHTS in the details indicating true love before marriage that abound in this print. The body language alone of this couple shows how much they adore each other as they both lean in to be closer to one another. They sing from a music-book entitled *Duets de l'Amour*. On the table is an open copy of Ovid's *Art of Love*. Even the goldfish look lovingly at each other. A picture on the wall of Cupid firing a blunderbuss at two doves is flanked by carvings of the crossed torches of Hymen and bows and arrows of Cupid.

<div align="right">

Harmony Before Matrimony
James Gillray; published by Hannah Humphrey
Hand-coloured etching, 1805

</div>

IN THIS COMPANION PIECE to *Harmony Before Matrimony* Gillray relishes his depiction of the discord that has now befallen the couple. The wife sits at the piano wailing out a song, while her husband, with his back to her, covers his ears and tries to read his newspaper, his mouth stuffed uncouthly with food. The cat and dog now hiss and growl at each other, mirroring their mistress and master's relationship, and the two cockatoos screech angrily in their cage. A nurse rushes in clutching a crying baby and waving a rattle. On the mantelpiece a carved ornament shows Cupid fast asleep, under a weeping willow, his torch upside down with arrows spilling from his quiver. To labour the point a thermometer reads almost freezing and a bust of Hymen, with a perplexed expression and a broken nose, is affixed to the wall.

<div align="right">

Matrimonial-Harmonics
James Gillray; published by Hannah Humphrey
Hand-coloured etching, 1805

</div>

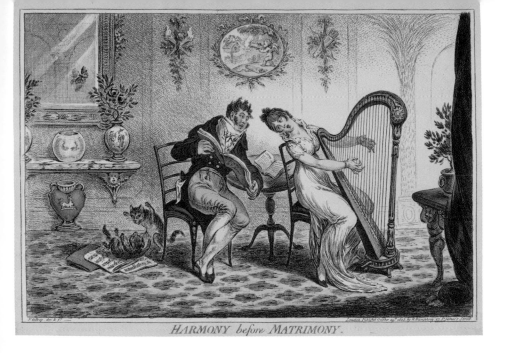

HARMONY before MATRIMONY.

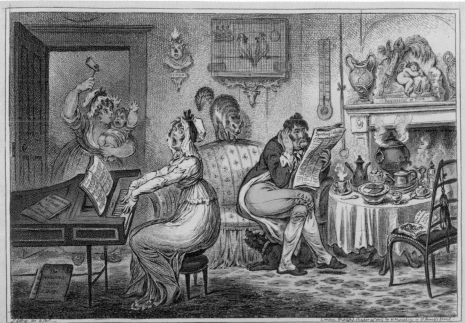

MATRIMONIAL-HARMONICS.

WHEN VIEWED one way round, this print shows a couple in profile smirking at each other, beneath which is the title 'Courtship'. The verse warns that the joyous state of love is but a temporary one for fools and how different things will be once the couple get married:

Courtship
When two fond fools together meet
Each look gives joy, each kiss so sweet
Pleasures the Burden of the song
Toying and playing all day long
When wed, now cold and cross they'll be
Turn upside down and then you'll see

When the print is turned upside down, the couple now frown at each other, cynically indicating that the true state of marriage is one of constant antagonism:

Marriage
That form once o'er with Angry Brow
The Marriage Pair both peevish grow
All night and day they scold and growl
She calls him Ass, he calls her fool
Thus oft we see in real life
Love ends, when once you're man and wife.

Courtship and Marriage
Engraving, 1770–1800

ILLUSTRATION REFERENCES

Photographs © The Trustees of the British Museum, courtesy of the
Departments of Prints and Drawings and of Photography and Imaging

page

2 PD 1935,0522.1.185 (BM Satires 6767)
8 (left) PD 1935,0522.1.126
8 (right) PD 1935,0522.1.127 (BM Satires 4540)
11 PD 1935,0522.1.62 (BM Satires 4564)
13 PD 1935,0522.1.31 (BM Satires 6160)
14 PD 1948,0214.343
17 PD 1948,0214.334
19 PD 1873,0712.882 (BM Satires 12407)
21 PD 1935,0522.1.199 (BM Satires 5822)
23 PD 1878,1012.401 (BM Satires 13135)
25 PD 1895,0617.454 (BM Satires 13454)
26 PD 1935,0522.1.70
29 PD 1868,0808.6927 (BM Satires 9752)
31 PD 1876,0708.2759 (BM Satires 5824)
32 PD 1935,0522.1.123 (BM Satires 4511)
34 PD 1935,0522.1.8 (BM Satires 4554)
37 PD 1935,0522.1.109 (BM Satires 7257)
39 1935,0522.1.80 (BM Satires 4504)
40 PD 1872,1012.5009 (BM Satires 11957)
43 PD 1981,U.243 (BM Satires 12646)
45 PD 1872,1012.4945 (BM Satires 11638)
46 PD 1935,0522.9.18 (BM Satires 9781)
49 PD 1872,1012.4981 (BM Satires 11783)
51 PD 1847,0508.19 (BM Satires 510)
53 PD 1868,0808.3837 (BM Satires 2875)
55 PD 1935,0522.2.1 (BM Satires 4495)
57 PD 1935,0522.1.136 (BM Satires 6762)
59 PD 1877,1013.878 (BM Satires 4780)
60 PD 1935,0522.1.128 (BM Satires 4548)
61 PD 1935,0522.1.129 (BM Satires 4549)

page

62 PD 1935,0522.5.9 (BM Satires 6932)
63 PD 1868,0808.5709 (BM Satires 7298)
65 PD 1868,0808.6150 (BM Satires 8058)
66 PD J.3.112 (BM Satires 9074).
 Given by Dorothea Banks
69 PD 1948,0214.385 (BM Satires 8219)
71 PD 1872,1012.5085 (BM Satires 11974)
73 PD 1878,0713.1310 (BM Satires 4596)
75 PD J.5.71 (BM Satires 5467).
 Given by Dorothea Banks
76 PD 1868,0822.7106 (BM Satires 6123).
 Bequeathed by Felix Slade
79 PD 1872,1012.5083 (BM Satires 12148)
81 PD 1990,1109.50
82 PD 1872,1012.5050 (BM Satires 12650)
84 PD 1872,1012.4930 (BM Satires 10909)
86 PD 2001,0520.16. Purchased with a
 contribution from the British Museum
 Friends
87 PD 2001,0520.15. Purchased with a
 contribution from the British Museum
 Friends
88 PD 1868,0808.6503 (BM Satires 8897)
91 PD 1935,0522.2.43 (BM Satires 5955)
93 (top) PD 1868,0822.7156 (BM Satires 10472).
 Bequeathed by Felix Slade
93 (bottom) PD 1868,0822.7157 (BM Satires
 10473). Bequeathed by Felix Slade
95 PD 1988,0514.17